calligraphy

MADE EASY

BY ASHLEY GARDNER | PRINTABLE WISDOM

Follow us on social media!

Tag us and use #piccadillyinc in your posts
for a chance to win monthly prizes!

© 2020 Piccadilly (USA) Inc.

This edition published by Piccadilly (USA) Inc.

Piccadilly (USA) Inc.
12702 Via Cortina, Suite 203
Del Mar, CA 92014
USA

10 9 8 7 6 5 4 3 2 1

Printed in Vietnam

ISBN-13: 978-1-60863-098-1

MADE EASY

Written by Ashley Gardner

Printable Wisdom
PrintableWisdomCo.com

TABLE OF CONTENTS

INTRODUCTION

Before we dive right in to learning the art of calligraphy lettering, let me tell you a little about myself! My name is Ashley Gardner, and together with my husband and business co-founder, I own Printable Wisdom. We started our business, creating hand lettered art and canvas prints, in 2012. Our business is based out of our hometown in Wylie, Texas, and every inch of the walls in our downtown flagship store is covered with hand lettered words turned into works of art.

I first became interested in calligraphy for our designs, when I noticed that using the popular "calligraphy fonts" never gave me exactly the look I was going for. I wanted something completely custom. I wanted to tailor the style and design of the words, to the message they were conveying. I quickly learned that hand lettering each piece was the only way to accomplish this.

So, in the summer of 2012, I browsed blogs and books to try and discover the best path to begin learning this age-old art. I quickly became overwhelmed by the wealth of information available. For months I experimented with various pen and ink types, learning which I enjoyed working with and which made me want to throw away every pen and paper in the house and never pick up a calligraphy pen again! Our kitchen table was regularly littered with endless papers filled with ink splotches and drafts of hand lettered designs.

After years of perfecting my hand lettering technique, I began passing this hard earned knowledge onto others. On social media @PrintableWisdom we regularly post tips for new calligraphers using the hashtag #nofusscalligraphy.

In our downtown shop, I host small bi-weekly calligraphy classes and over 100 students have completed our technique intensive Calligraphy Workshop.

With this book, Calligraphy Made Easy, I hope to make the art of calligraphy more accessible and cut out a lot of the experimentation and trial and error I went through to learn calligraphy. We will start by exploring some of the basic supplies you will need (and really all you'll need to get started is a pen!), how to prepare to write, and then we will dive right in to creating beautiful lettering.

I hope after completing this book, you fall in love with the art of hand lettering as much as I have.

Happy lettering!

SELECTING SUPPLIES

THE PAPER

When selecting paper for calligraphy, you will need to consider the type of pen you are using. We will discuss a few different paper types below.

When practicing calligraphy, regardless of pen type, I recommend choosing a smooth paper without natural fibers. This is because natural fiber papers tend to pick up and absorb excessive amounts of ink and this will cause your ink to run out quickly if you are practicing on this type of paper.

Plain printer paper: This is best for practicing if you are using a brush pen.

Card stock: This type of paper is also good for practicing if you are using a brush pen (the only difference is that your ink will not show through, so you can use both sides of the paper). I have also used card stock when using a nib + dip pen before.

Natural fiber paper: This is great for projects and adds a luxurious touch to pieces. Make sure to test your pen and/or ink before starting as some natural fiber papers (especially watercolor paper) tends to bleed and make your lettering look "fuzzy."

Watercolor paper: This can work with brush pens, but nib + dip pen writing tends to run on this type of paper. I rarely use watercolor paper unless I want to add a watercolor wash behind my pieces, and then I always use a brush pen.

THE PEN

The most important part of calligraphy! The type of pen you choose can greatly affect the way your lettering turns out. Below, we will discuss some types of pens (in two main categories - brush pens and dip pens) and my recommendations for each of them.

Brush Pens:

Felt tipped brush pens: These are my favorite pens for beginners. The tips are tapered and vary from stiff to flexible. My personal favorite is the Tombow Fudenosuke hard-tipped pen. Other options include the Tombow Fudenosuke soft-tipped pen, and the Pentel Sign Pen. The pieces from the Printable Wisdom shop shown below were created with these types of pens.

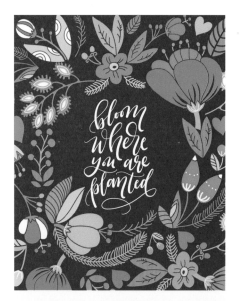
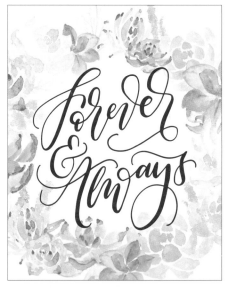

Tombow Dual Brush Pen:

This pen type deserves an entire section of its own! A favorite of handletterers, these pens come in a variety of colors and can be blended and combined to create beautiful ombre and shaded effects. One side of the pen is a non-calligraphy style fine tip, and the other is a large tapered brush pen. The designs shown below, from the Printable Wisdom shop, were created with Dual Brush Pens.

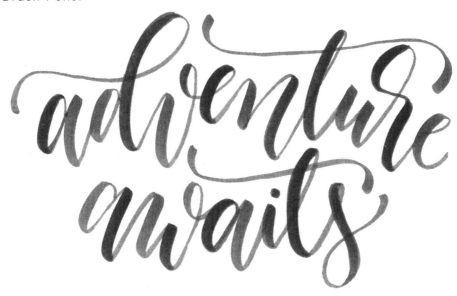

Paintbrush style pens:

These pens have individual brush fibers (like a traditional paintbrush) but they are attached to a pen. The Pentel Color Brush is a great example, and I love the version of this pen with black ink inside for giving a "dry brush" look to lettering, with prominent brush strokes (see "Hustle" design below). Another great option is the Pentel Waterbrush. This is an empty tube attached to a paintbrush tip. The tube is filled with water, and then the pen can be dipped onto dry watercolors, for easy and mess-free watercolor painting. The watercolor design below was created with this pen. And we can't leave out the tried and true old favorite, a regular old paintbrush! The best brushes for calligraphy are small and with shorter bristles.

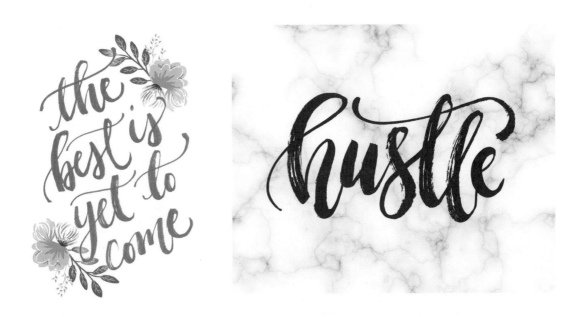

Dip Pens:

These are "traditional" calligraphy pens. The supplies needed to use these are as follows...

1. Nib - this is the metal piece that deposits ink onto the paper. Before using nibs, you should prepare them by running a lighted match over the surface to remove any oils. Always make sure you clean your nibs thoroughly after each use. My favorite nib is the Nikon G.
2. Ink - you dip the nib into the ink. There are a ton of options for ink, and experimentation is the best way to find your favorite. For a tried and true favorite, use Sumi Black ink.
3. Nib holder - This is the "pen" portion that you hold onto to write. These come in two varieties - straight and oblique. Oblique nib holders help you angle the pen more comfortably and are usually best for right-handed calligraphers.

For the purposes of this book, I do not recommend using a dip pen. The paper needed is much more temperamental and calligraphy created with nibs + ink takes a lot of time to dry. The piece below was created with nibs + ink.

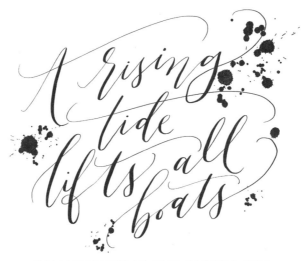

CALLIGRAPHY IN THE DIGITAL ERA:

With the recent interest in hand lettering, a whole new world of tools have become available for creating gorgeous lettering. My favorite tool for creating the most natural looking digital calligraphy is my tablet + stylus and the Procreate app for iPad Pro. The possibilities are endless for this method and the portability cannot be beat. The pieces below were created digitally.

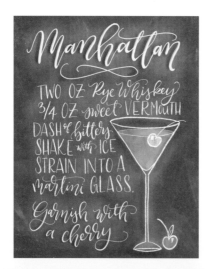

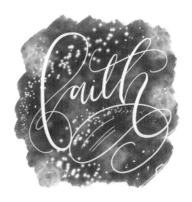

FOR THIS KIT:

For the purposes of completing the worksheets and projects in this kit, I recommend using a felt tipped brush pen. My personal recommendation is the TOMBOW FUDENOSUKE HARD TIPPED PEN.

Make sure to have a pencil and eraser handy, as well as some extra paper so you can practice the strokes for each exercise and plan out your letterforms for the projects towards the end of the book - soon you'll be creating gorgeous calligraphy designs just like the one shown below!

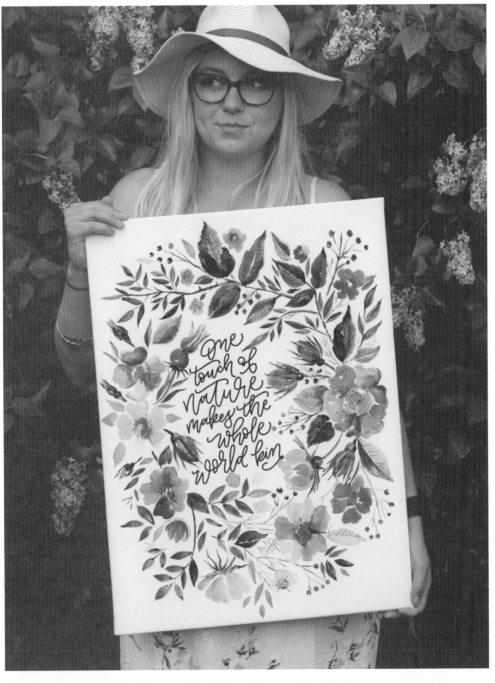

Photo Credit: Samantha Wils I Samantha Violet Photography

ANATOMY OF CALLIGRAPHY

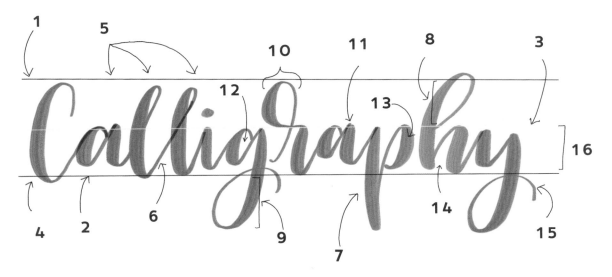

1. Capital / Ascender line: This is the line that your capital letters ("majuscules") and ascenders will rise to. Sometimes flourishes can be above this line as well.

2. Baseline: This is the line that your letters all "sit" on. For "modern" calligraphy the baseline can vary and some letters (like the "a"s in this example) can sit above the baseline.

3. Mean line: This is exactly in the middle of the Capital line and Baseline. Lowercase letters rise to this line.

4. Majuscule: This is another word for capital letters in calligraphy.

5. Miniscules: This is another word for lowercase letters in calligraphy.

6. Upstroke (this is also a connector): In calligraphy, upstrokes are THIN.

7. Downstroke: In calligraphy, downstrokes are THICK.

8. Ascender: This is a portion of a lowercase letter that rises above the mean line.

9. Descender: This is a portion of any letter that falls below the baseline.

10. Soft transition: This is where your stroke gradually transitions between thin and thick.

11. Sharp transition: This is where your stroke abruptly transitions between thin and thick. Usually you will pick up your pen between strokes on a sharp transition.

12. Void: This is another name for a "loop" in calligraphy.

13. Bowl: This is the curved shape often used in calligraphy (also seen on the "C", "a", and "g").

14. Counter: This is the blank space underneath the "h" seen here and in other letters.

15. End flourish: The decorative swash at the end of a letter.

16: X-height: This is the space between the baseline and mean line. Approximates the height of the miniscules.

PREPARATION

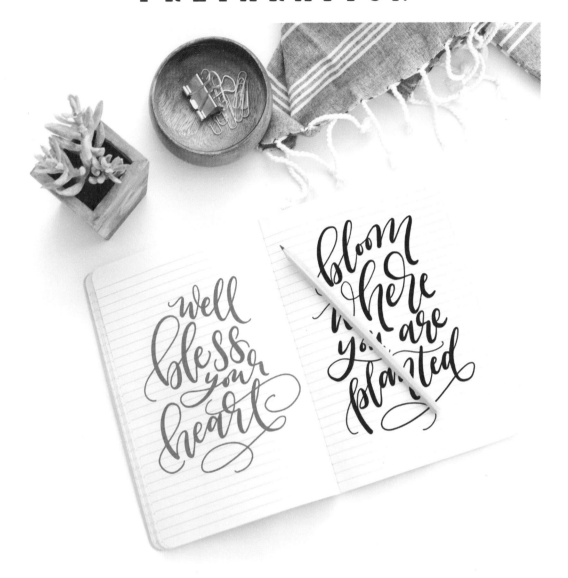

WRITING SURFACE
Make sure to pick a hard writing surface, with plenty of room to spread out - your elbows will be taking up a lot of room while you write!

HOLDING YOUR PEN
Hold your pen about 1 to 1.5 inches away from the tip, and make sure to hold it at a 45 degree angle to the paper.

SECURING YOUR PAPER
I like to use a clipboard to secure loose paper, or write in a notebook like the one pictured above.

LIGHTING
Ensure that the room you are in has good lighting. This will make it easier to spot crooked lines or gaps in your lettering that need to be filled in when perfecting your strokes.

R U L E S

These rules are mostly written for brush pens, but can also be applied to other types of calligraphy pens. Keep these in mind every time you pick up your pen to write!

1. Downstrokes are thick.

To get thick downstrokes, apply hard pressure to your brush pen while holding it at a 45 degree angle. The pen will flex against the paper as illustrated below, making a thick stroke. With dip pens, you get thick strokes by pushing hard, separating the tines of the nib (see right).

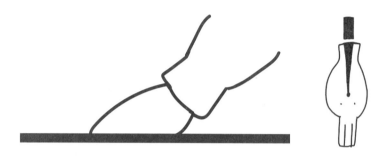

2. Upstrokes are thin.

To get thin upstrokes, apply almost no pressure to your brush pen while holding it at a 45 degree angle. Only the very tip of the pen will touch the paper as illustrated below, making a very thin line stroke. This is usually the hardest to master (in comparison to the thick strokes) and requires a lot of concentration. As you continue practicing, it will become less natural and more a matter of muscle memory. With dip pens, you get thin strokes by applying nearly no pressure, keeping the tines of the nib together (see right).

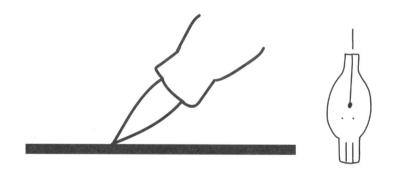

3. Pick up your pen between strokes.

Remember the "sharp" transitions our calligraphy anatomy lesson. You will pick your pen up between sharp transitions and whenever you are starting a new letter. This is different from "cursive writing" where a word is one continuous stroke.

4. Write slowly

This is the most important rule. Write very slowly. Especially with brush calligraphy, think of this as "drawing" and not "writing." You will take at least 10x longer to write each word if you are doing it right, and this is where I see most beginners become frustrated that they cannot get nice thin and thick strokes - usually because they are writing too fast.

THE 45 DEGREE ANGLE

When writing with a calligraphy pen, you should always hold your pen at a 45 degree angle to the page. No matter if you are applying light or heavy pressure to the pen, the body of the pen should always make this angle.

Below, we show the angle of the brush pen using a "stiff" brush pen. With heavy pressure, the pen makes a slightly thicker line, giving a modest contrast between thick and thin lines.

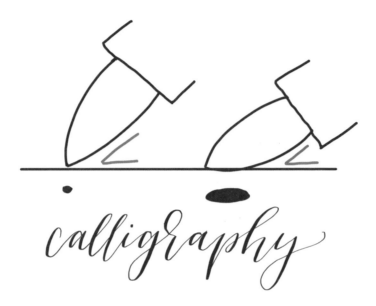

This next illustration shows a "paintbrush" or soft brush pen type. Notice that applying heavier pressure makes a much thicker line on the downstrokes. With this pen you get a big contrast between thin upstrokes and thick downstrokes.

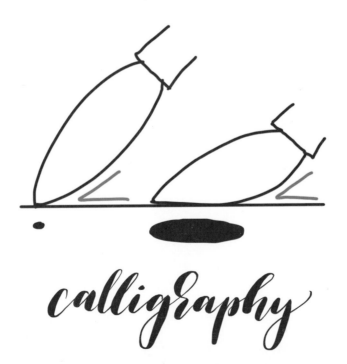

WARM-UP DRILLS

Having a set of drills to warm up with is a great way to start any calligraphy practice session.
This page is made up of pencil drills. By practicing these shapes and strokes,
you will develop muscle memory to create smooth lines and curves.

Try to imagine that your forearm, wrist, and hand are all moving together while drawing
these shapes. Most movement should come from your elbow, not your wrist.

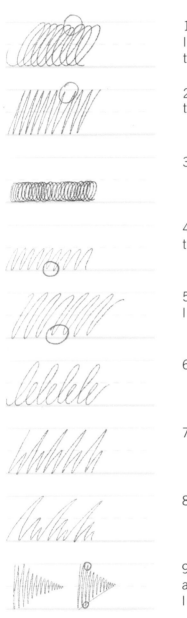

1. Swirls - make sure to fill the entire height of the practice lines (see red circle - where the loops don't quite reach the top - try to avoid this!)

2. Zig-zag - again, make sure to cover the entire distance of the practice lines.

3. Tight Loops

4. Short waves - Make sure that each wave ends on the baseline and rises to the dotted line.

5. Tall waves - Make sure that each wave ends on the baseline and rises to the capital line.

6. Alternating loops

7. Alternating zig-zags

8. Decrescendo zig-zags

9. Conical zig-zags - Try and make each zig-zag with less amplitude, so that the edge ends up looking like a straight line.

10. Conical loops

11. Decrescendo waves

WARM-UP DRILLS

These drills are to be done with your calligraphy pen.

I recommend using a brush pen for the remainder of the book.
See "Pen Types" for recommendations.

1. Upstrokes - use very light pressure!

2. Downstrokes - use heavy pressure!

3. Sharp transitions - Pick up your pen in between each up and down stroke

4. Smooth transitions - Start transitioning from light to heavy or heavy to light where each of the red arrows are drawn (always start your dark to light early)

5. Thick to thin transitions - start lightening up on the pressure about 75% of the way through your downstroke.

6. Thin to thick transitions - start applying more pressure at the very top of the shape.

7. Thick-thin-thick waves

8. Thick-thin-thick flourish - start changing the pressure on your pen where the red lines are shown.

9. Conical loops - Practice naturally varying the pressure applied. This is great for developing muscle memory!

10. Sharp transition curves - Pick up your pen at the top of each point.

11. Ending "points" - Great for learning how to make "points" at the end of words.

WARM-UP DRILLS

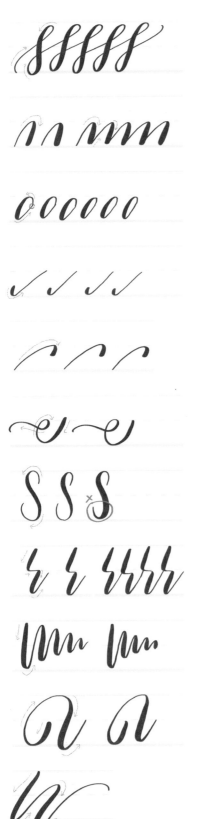

1. Dancing S - This drill helps you develop a feel for the "angle" that calligraphy is written at.

2. Hills - combine the thin to thick stroke and create the illusion of one continuous line.

3. Ovals - these are very important in nearly all letters. Start your oval where the red circle is drawn and bring the line back to connect at this point.

4. Checks - great for developing the stroke to create a "point" on the beginning of a word.

5. Flipped Checks

6. Reverse flourish - this is a good trick for writing from right to left (which we do frequently when adding flourishes)

7. Letter S - to practice your thin-thick-thin transition while writing on a curve. Avoid starting your thick to thin transition too late (see last letter)

8. Dancing "r" - lines that are horizontal are thin, just like upstrokes.

9. Decrescendo waves

10. Open flourish

11. Leaning W

WARM-UP DRILLS

minimum

1. Minimum - See strokes above that make up the word "minimum" - this is a great drill for combining multiple strokes.

2. "oioioi"

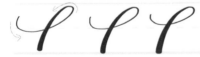

2. Combine the "oioioi" strokes to make a string of the letter "a"

4. Underlining flourish

5. Reverse underlining flourish

6. Angled zig-zag - this is a great drill to practice if you are trying to develop a more "flowing" calligraphy style

7. Opening flourish from below

8. Opening flourish from above

9. Closing flourish

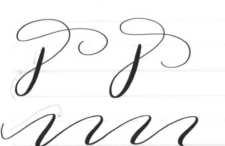

10. Rolling hills

MINISCULES

a a a a a

b b b b b

c c c

d d d d d

e e e

f f f f f

g g g g g

h h h h h

i i i

j j j

k k k k k

Over the next several pages, use the light grey strokes to trace on the left page, and then practice the letterforms yourself on the blank lines following.

l l l

m m m m m

n n n n n

o o o

p p p p

q q q q q

R R R

s s s

l t t t

u u u u u

v v v v v

26

w w w w w w

x x x x x

y y y y y

z z z z z

"S" IN THE MIDDLE OF A WORD ⟶ *s s s s*

Use the connector from the previous letter as the opening stroke for the "s"

"R" IN THE MIDDLE OF A WORD ⟶ *r r r r*

Use the connector from the previous letter as the opening stroke for the "r"

i s is is is

o r or or or

b o s s bass bass

c o r car car

s r sr sr sr

MINISCULE ALTERNATES

There is more than one way to write each letter in calligraphy!
Here are some alternate letterforms for the miniscules. Learning alternate letterforms will
help your calligraphy look more fluid and natural.

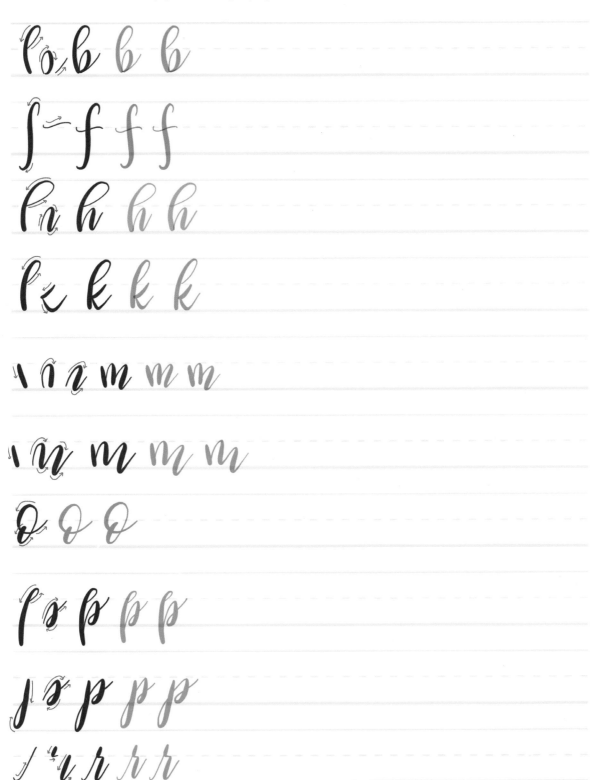

s s s s s

s s s

l t t t t

v v v v

w w w w

m m m m m

o o o o

x x x x

y y y y y

z z z

Ol a a a

1 3 B B B

C C C

1 D D D D D

c E E E

F F F F

G G G G

H H H H H

I I I

J J J

K K K K

Capital letters in calligraphy are called "majuscules." There are countless ways to write majuscules and on these next few pages I'll show you some of my favorites. Alternate letterforms will also be included so you can pick your favorite style for each letter.

$\mathcal{L} \mathcal{L} \mathcal{L}$

$\mathcal{M} \mathcal{M} \mathcal{M} \mathcal{M} \mathcal{M}$

$\mathcal{N} \mathcal{N} \mathcal{N} \mathcal{N} \mathcal{N}$

$\mathcal{O} \mathcal{O} \mathcal{O}$

$\mathcal{P} \mathcal{P} \mathcal{P} \mathcal{P} \mathcal{P}$

$\mathcal{Q} \mathcal{Q} \mathcal{Q} \mathcal{Q}$

$\mathcal{R} \mathcal{R} \mathcal{R} \mathcal{R} \mathcal{R}$

$\mathcal{S} \mathcal{S} \mathcal{S} \mathcal{S} \mathcal{S}$

$\mathcal{T} \mathcal{T} \mathcal{T}$

$\mathcal{U} \mathcal{U} \mathcal{U} \mathcal{U} \mathcal{U}$

$\mathcal{V} \mathcal{V} \mathcal{V}$

W W W W

V X X X X

Y Y Y Y Y

Z Z Z Z

ALTERNATES

N N A A A

B B B B

C C C

D D D D D

E E E

S S S

I I I I I

K K K K K

L L L L

M M M M M M

N N N N N N

O O O

P P P P P

R R R R R

S S S

S S S S S

S S S

S S S

t T T T

u u u u

v v v

w w w w

y y y y y

z z z z

z z z z

NUMBERS

123 123

456 456

78 78

90 90

DEVELOPING ALTERNATES

Here, you'll learn how to create your own alternate letterforms! There are a few tricks to quickly changing the look and feel of a letter by varying slight characteristics.

1. Change the angle of the downstrokes.

2. Change the size of the "voids"

3. Change the angle of the "voids"

4. Add loops

5. Change the baseline of your letter

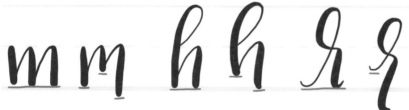

6. Add flourishes

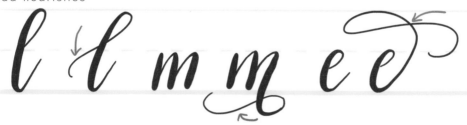

CONNECTING LETTERS

Up until now, we have been including "connector" strokes on the end of every letter. The connector stroke is the last thin upstroke shown on every letterform. These strokes are important because they add space between your letters.

When connecting letters, you have a few different choices on how you want to connect them. The important things to keep in mind are the baseline that the letters sit on, and the baseline of the connectors.

CONSERVATIVE CONNECTIONS
All letters and connectors on same baseline

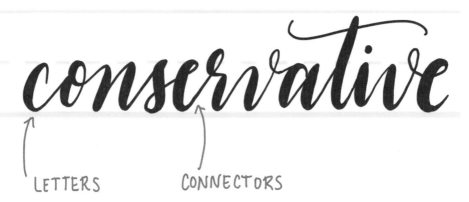

LETTERS CONNECTORS

MODERATE CONNECTIONS
All letters on same baseline. Connectors on different baselines

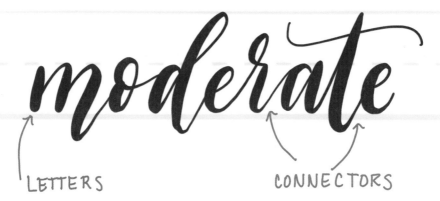

LETTERS CONNECTORS

LIBERAL CONNECTIONS
Letters on different baselines. Connectors on different baselines

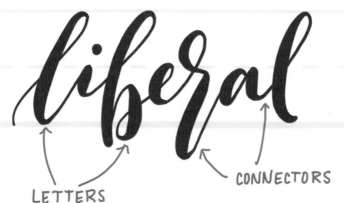

CONNECTORS

LETTERS

PRACTICE CONNECTIONS

PRACTICE CONNECTIONS

flower flower

shore shore

tree tree

baby baby

kitchen kitchen

doll doll

class class

phone phone

world world

share share

test test

love love

hope hope

faith faith

grace grace

best best

mother mother

happy happy

courage courage

strong strong

luck luck

home home

Mr. Mr.

Mrs. Mrs.

State State

Calligraphy Calligraphy

Flourish Flourish

Patience Patience

Love Love

Hope Hope

Garden Garden

Mother. Mother.

Hello Hello

FLOURISHES

These pages will show you flourishes for you to use when starting words, in the middle of words, and when ending words. This is by no means an exhaustive collection of flourishes, and many extra decorative strokes will be added organically as you create compositions to fill empty spaces between words and lines.

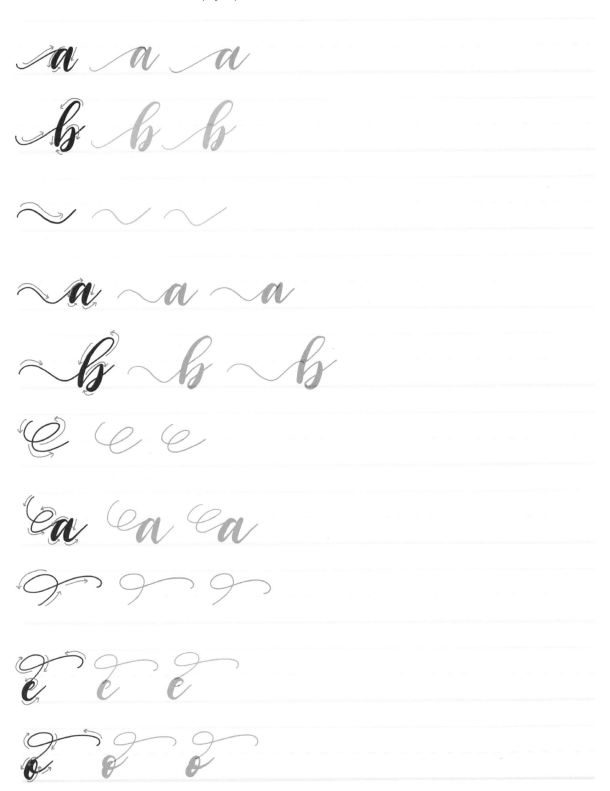

l *l* *l*

m *m* *m*

p *p* *p*

ℓ ℓ ℓ

ea *ea* *ea*

f *f* *f*

ℰ ℰ ℰ

ea *ea* *ea*

C *C* *C*

Ca *Ca* *Ca*

Cb *Cb* *Cb*

ℓ ℓ ℓ ℓ

d d d d

f f f f

g g g g

j j j j

h h h h

k k k k

m m m m

r r r r

t t t t

t t t t

\mathcal{T} \mathcal{T} \mathcal{T} \mathcal{T}

\mathcal{T} \mathcal{T} \mathcal{T} \mathcal{T}

η η η η

ψ ψ ψ ψ

\mathcal{Q} \mathcal{Q} \mathcal{Q} \mathcal{Q}

\mathcal{S} \mathcal{S} \mathcal{S}

\mathcal{Y} \mathcal{Y} \mathcal{Y}

η η η

\mathcal{C} \mathcal{C} \mathcal{C}

\mathcal{J} \mathcal{J} \mathcal{J}

m m m

a a a

e e e

a a a

a a a

d d d

f f f

h h h

k k k

y y y

g g g

g g g

TROUBLESHOOTING

Here, we will discuss common problems or mistakes that come up when first learning calligraphy. These troubles usually happen when first starting out, and diminish over time as you become more comfortable with using your pen. Here, we will give some tips to help overcome these "growing pains" of learning calligraphy.

PROBLEM #1: THICK STROKES "BLEED INTO" THIN STROKES
This commonly happens when you start transitioning to thin too late in your lettering. Try starting to transition to a thin upstroke about 75% of the way into your downstroke (i.e. before you get to the very bottom of the baseline).

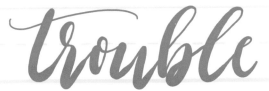

PROBLEM #2: LETTERS ARE TOO CLOSE TOGETHER IN WORDS
This problem happens when you make your connecting strokes too short. Make sure to extend your connecting line every time you write a letter and try to keep the connectors consistent so your letters will be evenly spaced.

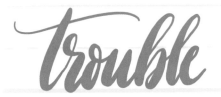

PROBLEM #3: FLOURISHES LOOK "STRAINED" AND "NOT NATURAL"
Avoid small loops and changing directions too many times in your flourishes. Try to use flourishes shown as examples on the prior pages (and ones you have perfected on your own).

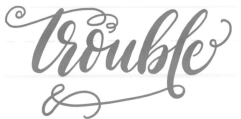

PROBLEM #4: WORDS TILT UP OR DOWN WHEN THEY SHOULDN'T
This happens when you write quickly without paying attention to your baseline. Practicing on lined paper like the paper in this book can help you develop a sense of keeping a consistent baseline, even when writing on blank paper.

PROBLEM #5: LETTERING LOOKS "STREAKY" OR LIKE YOUR PEN HAS DRIED UP
This is often caused by writing too quickly. Remember the rules of calligraphy - write slowly and deliberately, thinking of your calligraphy as drawing instead of writing.

On this page, practice "fixing" the flawed lettering on the opposite page.

COMPOSITIONS

Now that you have practiced letters, connections, and flourishes, you are ready to bring it all together to create a design - or a "composition." Here, we will walk through the steps to create a basic composition. Before beginning, it is important to choose a quote that is the right length for your project.

Below are the steps you should walk through every time you create
a new composition, in this order.

1. Choose which words you want to emphasize. Speak the quote aloud and notice which words you pause on and which words are most important to the meaning of the piece. Here, I chose "create" "things" and "existed" but could have also chosen "wish" and/or "you" depending on what message I wanted to convey. These words you choose will be the biggest in your project. Write them out and make sure to leave enough approximate space to fill in smaller words later. In this piece, you will see that I wrote the middle word first ("things") to make sure that my composition was well balanced and didn't end up on the top or bottom of the page.

2. Now write in smaller words to sit among your emphasized words. These do not all have to be the same size - some can be tiny and some can be medium sized as well. Here, I use a mix of printed letters and calligraphy letters. Keep the next steps in mind when adding these smaller "supporting" words.

3. Use the cross bars on lowercase "t" and "x" to fill in extra space in this example.

4. Use flourishes on descenders to fill in negative space like in the ending "d" of this example. This helps the piece look more balanced.

5. You can have curved baselines when creating a composition so that the piece looks balanced in the end. Notice how "things" slants up to the right more than "create" or "existed."

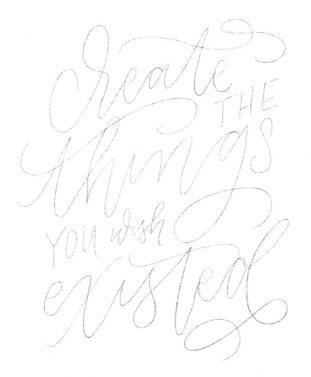

Note: It can be helpful to write your composition in pencil first, to plan out where you will place words. Here is my initial sketch of this composition that I used when following the steps on the next page.

things

create
things

create
things
existed

create the
things
you wish
existed

create the
things
you wish
existed

COMPOSITION EXERCISE

Now, practice creating your own composition. You can trace the design on this page to get the feel for adding words out of order. On the next page, create your own composition using the steps explained on the prior pages.

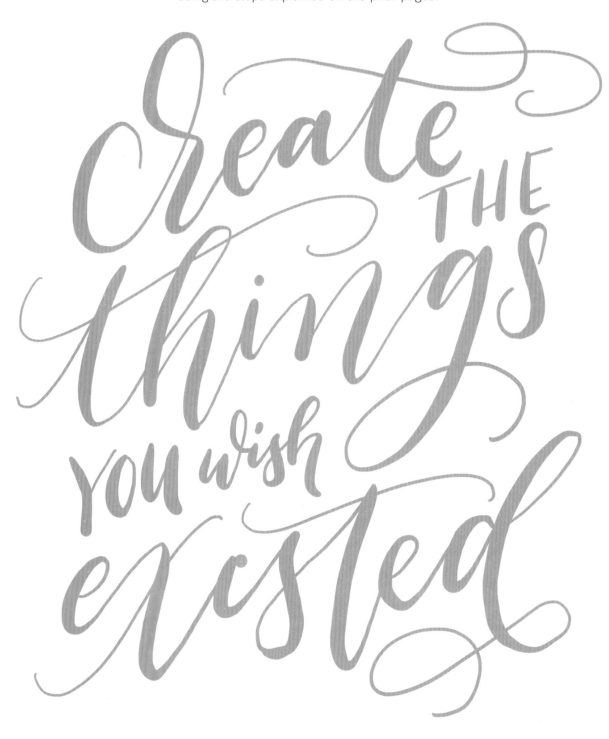

Tip: Try to picture the words in your head before starting to estimate the space you'll need between words.

calligraphy

PROJECTS 1-30

P R O J E C T # 1

The rest of this book consists of projects. The first page will have an example
project, followed by a practice page and another page on the right will be where you
create your own works of art.

Project #1 consists of a calligraphy majuscule in a framed wreath.
Write the first letter of your name, or your favorite majuscule letterform
in the wreath on the following pages.

PROJECT #2

Now we'll practice writing a composition. Write the same words shown here on your project sheet, or choose a new message to include on the typewriter page!

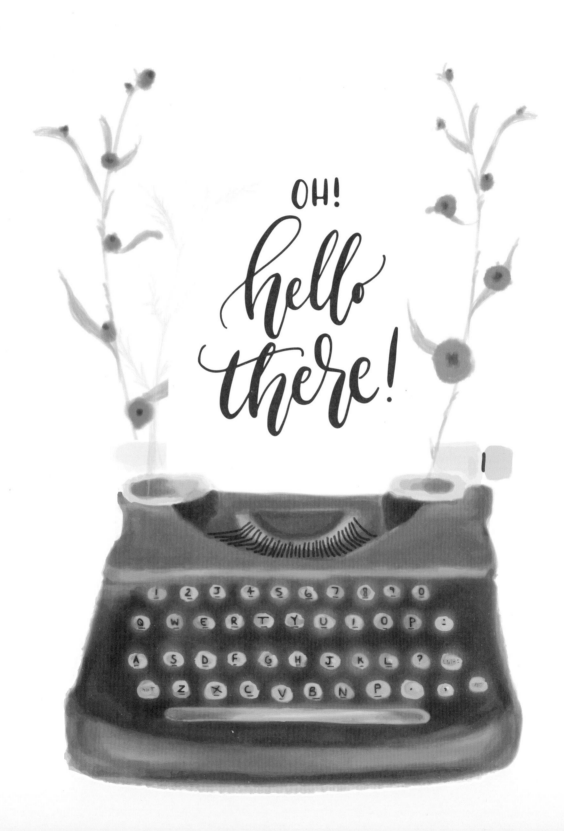

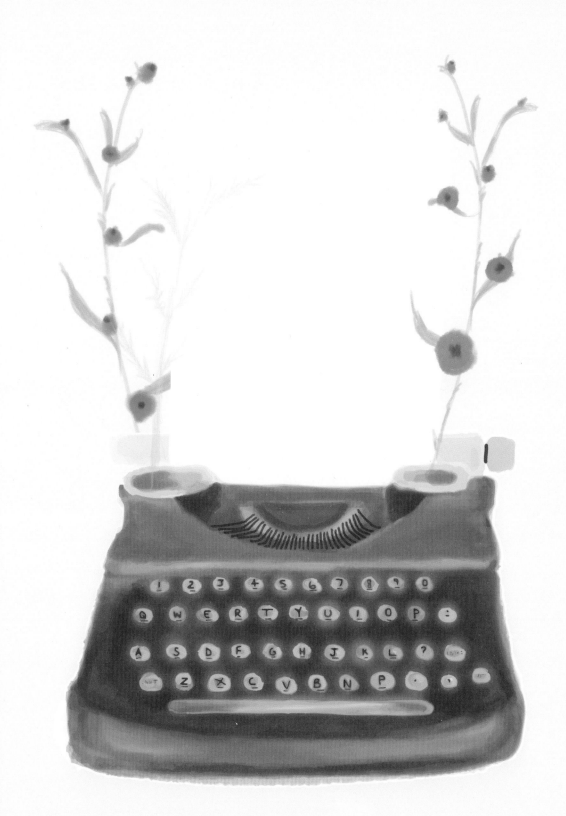

P R O J E C T # 3

For this project, choose a miniscule letterform. Now write it in the circle with an opening and ending flourish so the entire letter stretches across the diameter of the circle.

PROJECT #4

Similar to project #3, but with a short word. Include an opening and ending flourish to make your entire word fill the diameter of the circle.

PROJECT #5

For this composition, the word "wild" is written in block lettering.
I varied the height of the letters in "wild" to make them fill the entire
space between the words written in calligraphy.

live on the WILD side!

PROJECT #6

For this project, write your name (or any word) with an ending flourish that also serves as an underlining flourish. For extra thick downstrokes, as shown here, go over your downstrokes after you're done with writing the word, making them twice as bold.

PROJECT #7

In the middle of the wreath, write a letter in any style you choose (I like looking at serif fonts for inspiration). Then in the banner below write your name/lettering in monoline calligraphy style (without thick and thin lines).

PROJECT #8

This project will let you practice "filling" spaces with your lettering. Try and make your quote fill the entirety of the circle made by the wreath. Use flourishes and alter your baseline to achieve this.

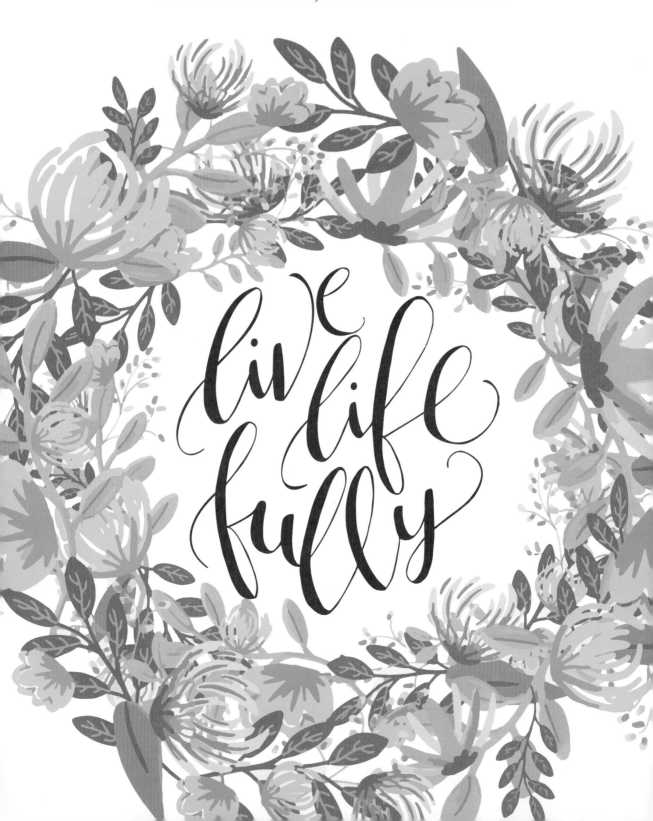

PROJECT #9

For this project, flourishes abound! Fill the edges of your composition with some of your favorite flourishes to echo the natural curves of the sketched wreath.

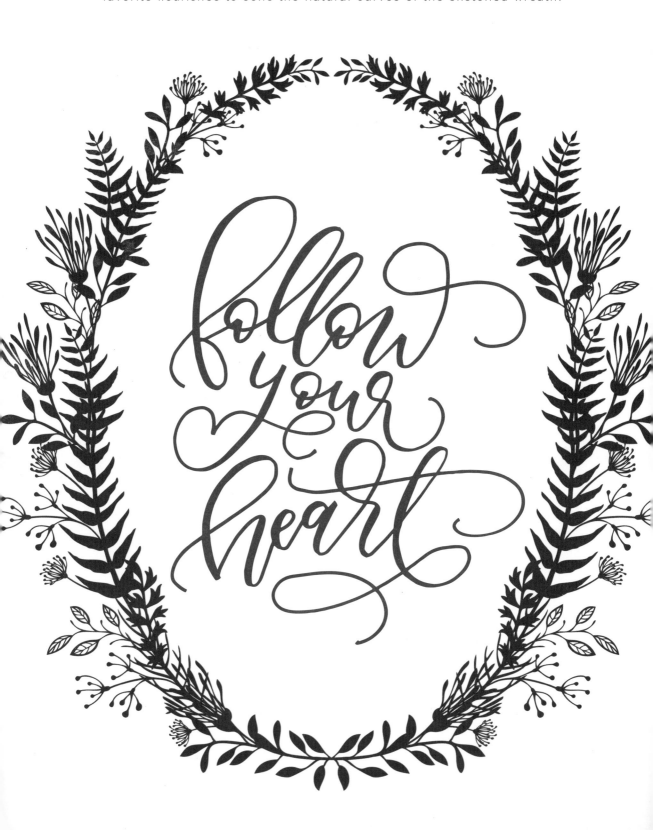

PROJECT #10

On this design, the goal is to balance the illustration at the bottom of the page, with your lettering above. Try writing the word "sweet" first, to make sure your composition is balanced on the page.

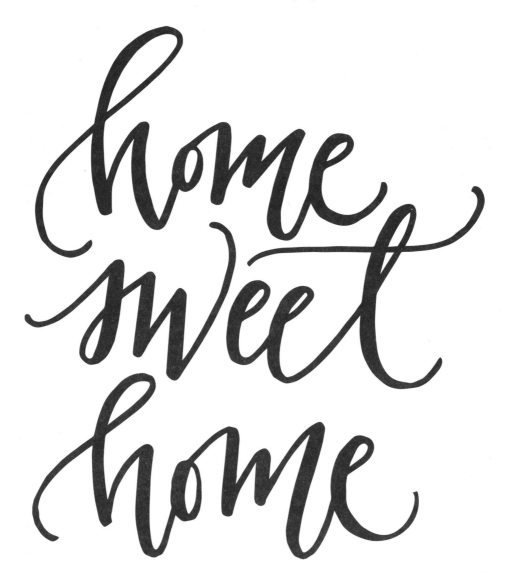

PROJECT #11

This design features a heavily-flourished majuscule in the center of the wreath and calligraphy style print lettering on the banner below. Use thick and thin lines to create the print letters the same as you do when writing calligraphy, but with straight lines and right angles.

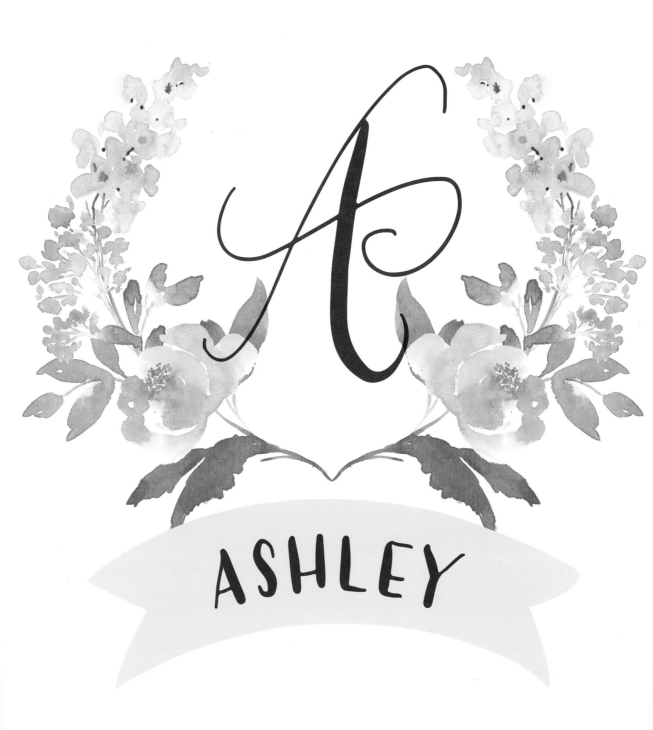

PROJECT #12

This project helps you practice flourishes. Choose one word to write and add opening and ending flourishes to take up the entire width of the page.

PROJECT #13

In this composition, we focus on filling up the empty space of the wreath. Write the ampersand (&) last so it fits in perfectly between your words.

PROJECT #14

Write the words in this composition out of order to balance the design. I wrote "where" and "planted" first and then filled in the other words to fit in amongst them.

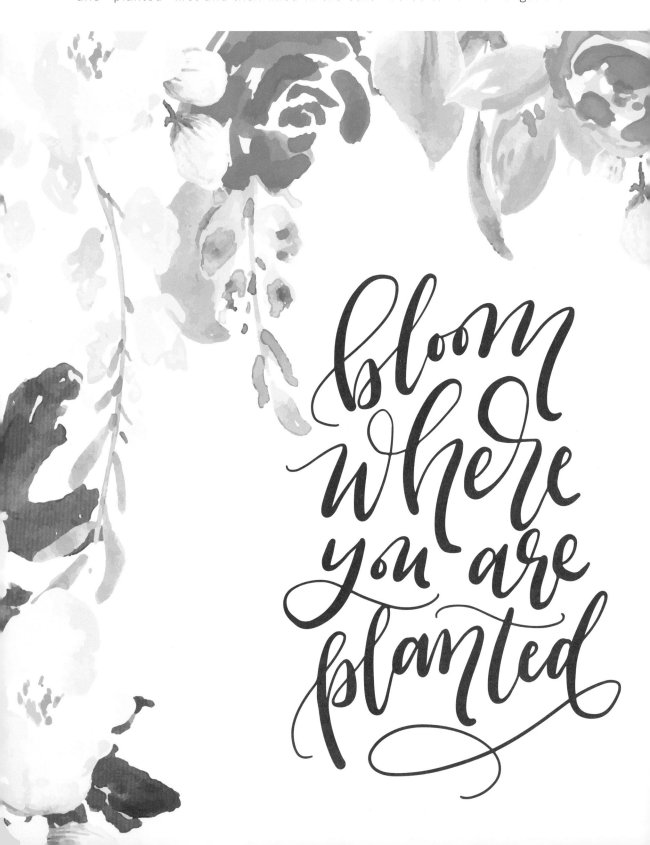

bloom where you are planted

On this design, alter your baseline for the words "well" and "your" to fill in spaces between the words "bless" and "heart."

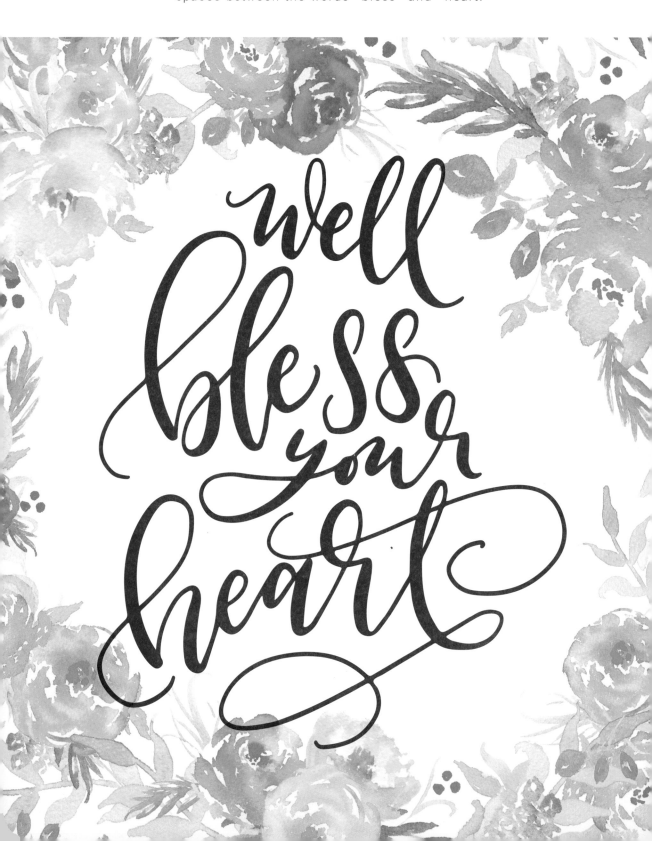

PROJECT #16

This design features an ending flourish that also serves as an underlining accent.

PROJECT #17

This simple design gets back to basics. Use classic letterforms and fill in the negative space in the design with your lettering.

PROJECT #18

On this design, go over your downstrokes a second time to make them extra thick.

go forth with grace

PROJECT #19

On this design, write your lettering with only thin lines.
This is called "monoline" lettering.

PROJECT #20

On this project, your flourish incorporates the floral design. Make sure to have a flourish go past the bouquet to integrate it into your lettering and create the illusion that the bouquet is "growing" out of your letterform.

PROJECT #21

Practice writing on a slanted baseline.

PROJECT #22

For this project, practice combining calligraphy and print lettering to fill in the oddly shaped negative space between the floral designs.

MAY *the* road RISE *to* meet YOU.

IRISH BLESSING

PROJECT #24

This is a very advanced composition piece. For this design, write accent words first (people, agreeable, trouble, deal). Then fill in the empty spaces with the remaining words. I recommend writing this with pencil first to plan your spacing.

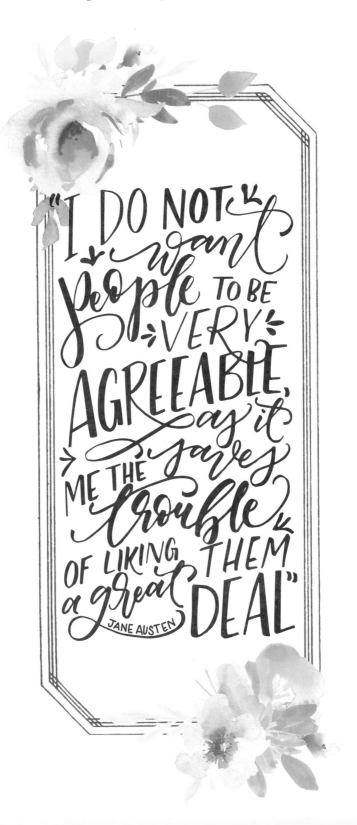

"I DO NOT want people TO BE VERY AGREEABLE, say it saves ME THE trouble OF LIKING a great THEM DEAL"

JANE AUSTEN

PROJECT #25

For this design you can create "faux" ink splotches. Just draw circles and add "spikes" to the outside of them and splatters moving away to create the illusion of ink splatters.

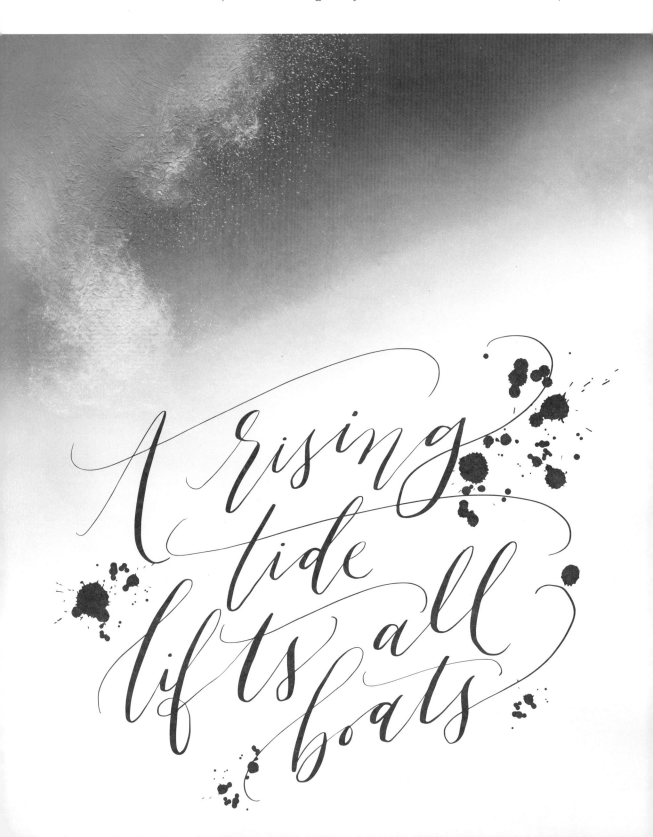

PROJECT #26

On this design, don't be afraid to let your lettering slightly extend out of the white diamond. This adds a fun, modern touch.

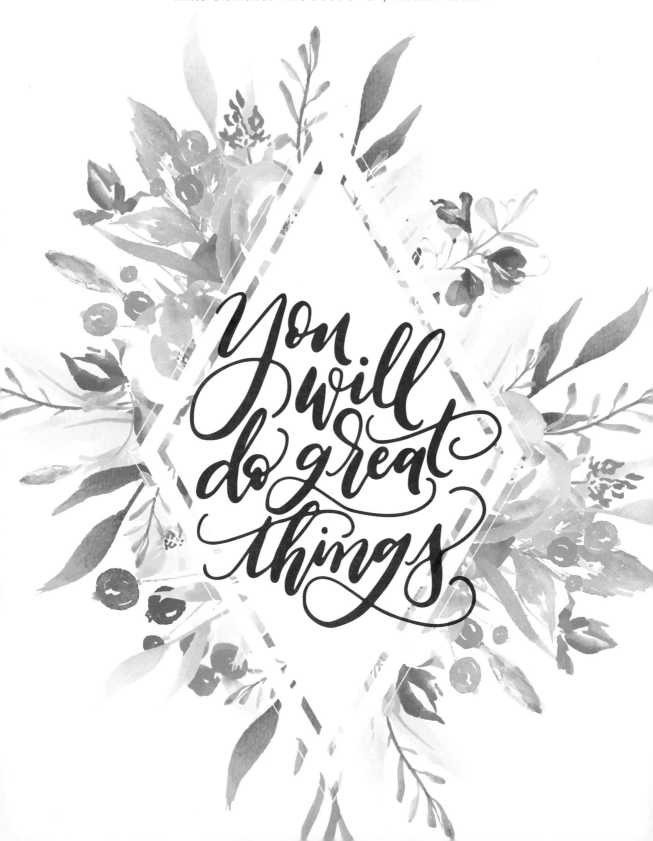

PROJECT #27

This composition is a classic combination of calligraphy words all in the same general size. Write the words "everyone" and "fighting" first to plan your piece.

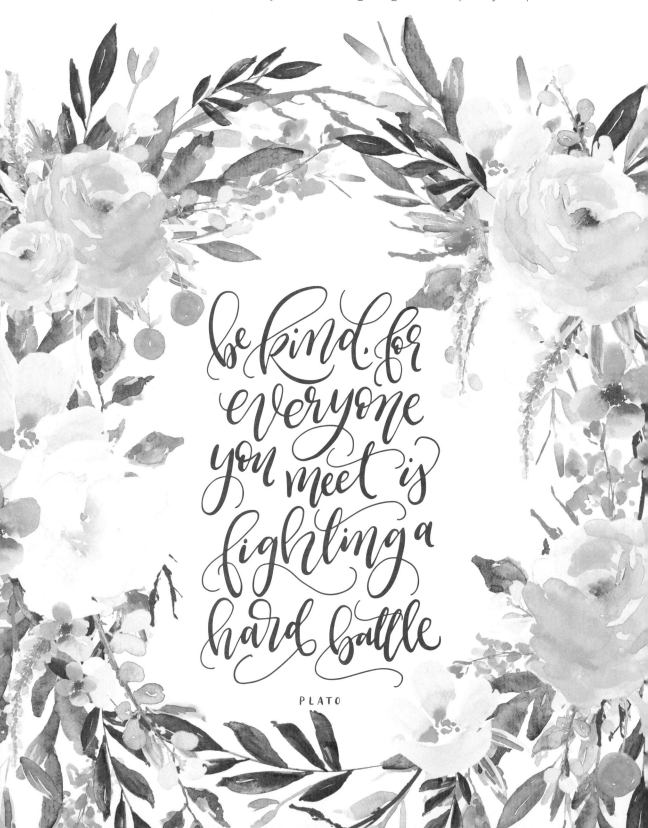

be kind, for everyone you meet is fighting a hard battle

PLATO

PROJECT #28

Practice varying the sizes of your letters here. The "r" in grace and "s" in abounds are extra large, adding a whimsical touch to these words.

PROJECT #29

Turn your page sideways to create a fun effect of vertical lettering.

PROJECT #30

Use "monoline" thin lettering to fill in the space in this natural floral wreath design.
Use the quote shown below, or pick your favorite nature themed quote for this piece.

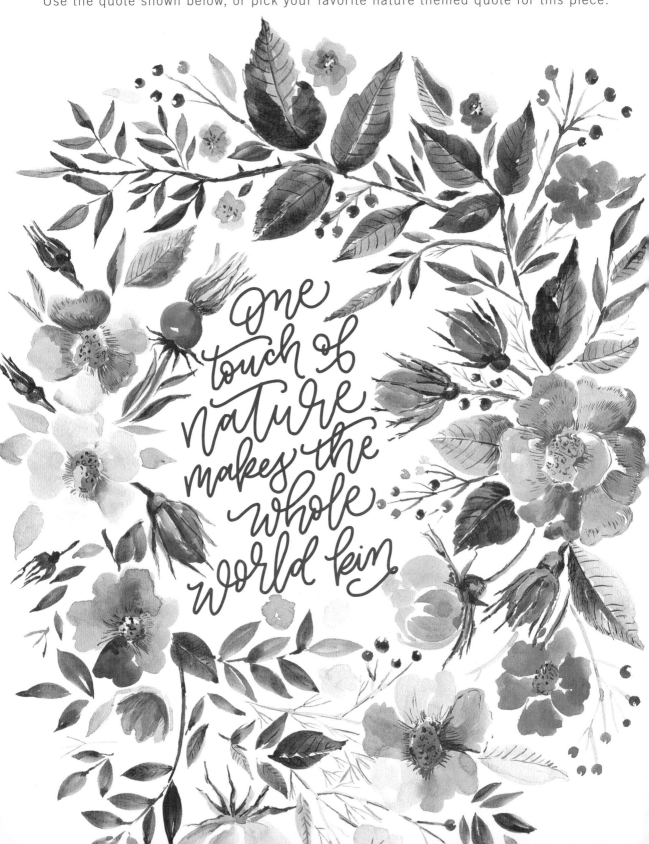

calligraphy

PRACTICE PAGES

Looking for more?

Other best-selling products from Piccadilly

300 Writing Prompts

300 MORE Writing Prompts

Sketch Your Sticker

Comic Sketchbook

300 Drawing Prompts

Calligraphy Made Easy

3000 Questions About Me

Your Father's Story

3000 Questions About My Future

500 Creative Prompts!

A Journey Within

The Fearless Woman

Church Notes

Complete the Story

Create + Destroy

Write the Poem

Write the Story

Your Mother's Story

3000 What If? Questions

8-in-1 Sketchbook

Complete the Drawing